THE MUCHA POSTER
Coloring Book

37 Designs Rendered for Coloring by

Ed Sibbett, Jr.

Dover Publications, Inc., New York

Published in Canada by General Publishing
Company, Ltd., 30 Lesmill Road, Don Mills,
Toronto, Ontario.
Published in the United Kingdom by Constable
and Company, Ltd., 10 Orange Street, London
WC2H 7EG.

The Mucha Poster Coloring Book is a new
work, first published by Dover Publications, Inc.,
in 1977.

DOVER *Pictorial Archive* SERIES

The Mucha Poster Coloring Book belongs to
the Dover Pictorial Archive Series. Up to four
illustrations from this book may be used on any
one project or in any single publication, free and
without special permission. Wherever possible
please include a credit line indicating the title
of this book, artist and publisher. Please address
the publisher for permission to make more exten-
sive use of illustrations than that authorized
above.
The republication of this book in whole is
prohibited.

International Standard Book Number: 0-486-23444-4

Manufactured in the United States of America
Dover Publications, Inc.
180 Varick Street
New York, N.Y. 10014

PUBLISHER'S NOTE

Between the years 1895 and 1904—the heart of the Belle Epoque—French poster and decorative art was dominated by the Moravian artist Alphonse Marie Mucha. His work had such hold on the public imagination that the whole style was, for a while, known as *le style Mucha* rather than by the now familiar term Art Nouveau.

Mucha was born in the town of Ivančice in 1860. He showed his bent toward art in infancy. His family did not encourage a career in art; in 1875, at his father's urging, he took a post as a court clerk. At the same time he applied to the Academy in Prague, but was rejected. In 1879 he left to join the workshop of Burghardt-Kautsky and Brioschi in Vienna as a trainee scene painter. When the firm's main client, the Ring Theater, burned down in 1881, Mucha was laid off. He then launched himself on his own career as an artist. One patron, Count Khuen, was so impressed with the young man's work that, in 1885, he subsidized his study at the Academy in Munich. Mucha then studied at the Académie Julian in Paris from 1887 to 1889. Thereafter Mucha eked out a living as an illustrator, gaining a reputation for reliability and competence, if not for brilliance.

In December 1894 Mucha received a commission to execute a poster advertising Sarah Bernhardt in Sardou's *Gismonda*. In it he used a completely new style containing elements which became Mucha hallmarks—the strong, sensuous line, the use of a halo or arched framework to set off the head, elaborate hair and drapery, mosaic patterns and motifs. Subsequently, Mucha became closely associated with Bernhardt, doing nine posters for her in five years. He also designed sets and costumes for her productions, offered advice on her personal wardrobe and even designed jewelry for her. As his fame grew, he was inundated with commissions and his output reached prolific proportions. Not only did he execute commercial posters for a wide variety of companies, including Moët et Chandon, Job cigarette papers, and Nestlé, but he also churned out decorations for menus, programs and book illustrations. He also created a wide variety of *panneaux décoratifs*—designs printed on paper or material such as silk and hung in homes or shops.

Although Mucha was making a good deal of money, he was unable to hold on to any of it; he managed his finances poorly and was a notoriously easy touch. His real ambition was to return to his homeland and devote his talents to works using the Czech people as a theme, but to do this he would have to make himself financially secure. In an attempt to shore up his finances, he made several trips to the United States. Although his plans were not as successful as he had hoped, in 1909 he did manage to gain the backing of Charles R. Crane to execute *The Slav Epic,* a series of twenty huge canvasses depicting the development of the Slavic peoples and their culture. Moving to Bohemia, he proceeded with the enormous task, finishing the first canvas in 1912. He also did works for the government, such as bank notes and postage stamps. The *Epic* was completed in 1928. Mucha died in Prague eleven years later.

After a period of eclipse, his work, along with that of the other Art Nouveau artists, is enjoying a great resurgence of popularity. For this book Ed Sibbett, Jr., has faithfully rendered for coloring the best of Mucha's work from his peak years. Mucha himself employed soft, rather muted color, as seen on the covers, but these beautiful, sensuous designs will respond equally well to other color schemes.

LIST OF SOURCES

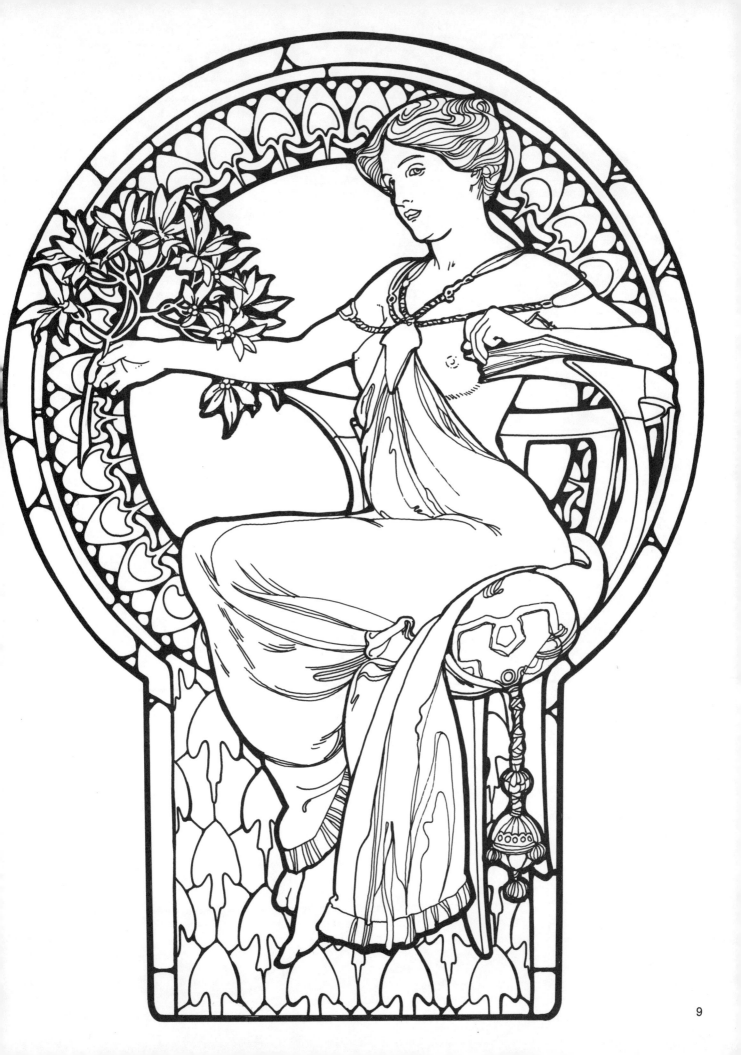

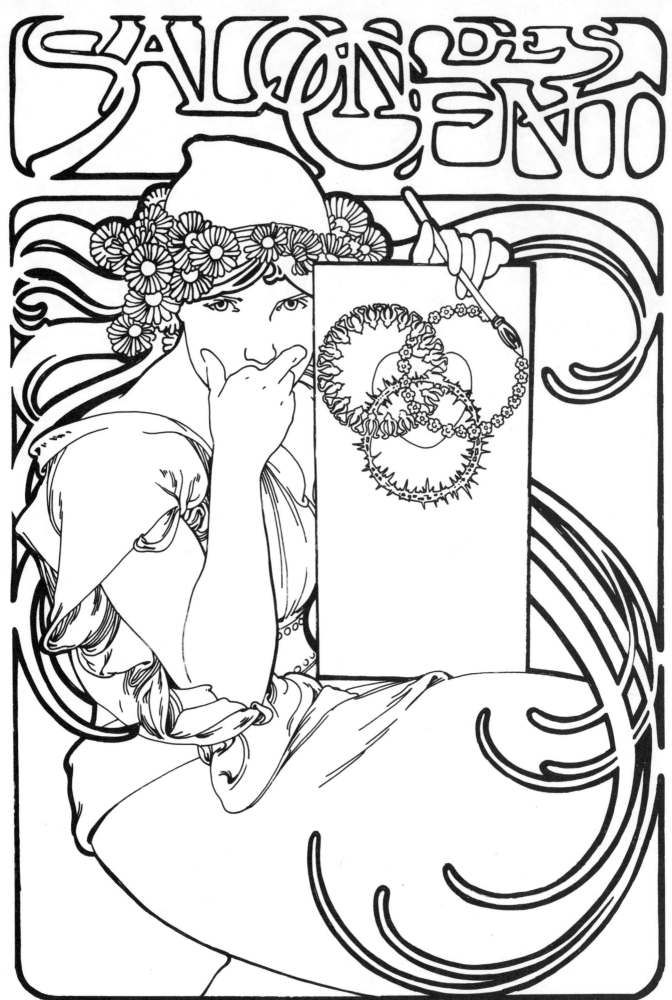

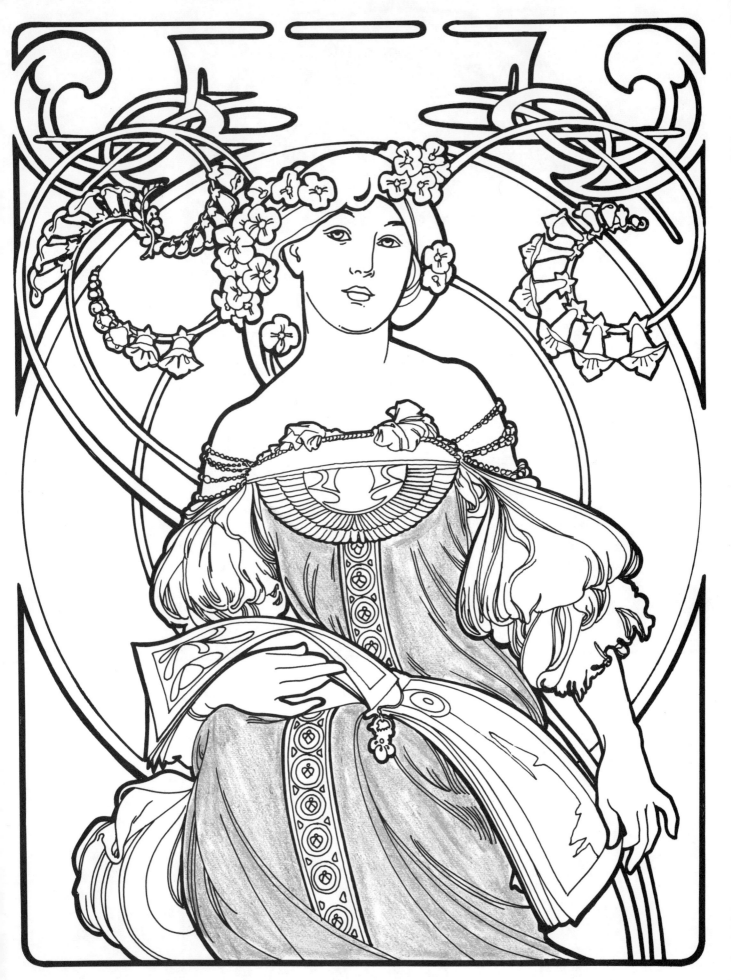

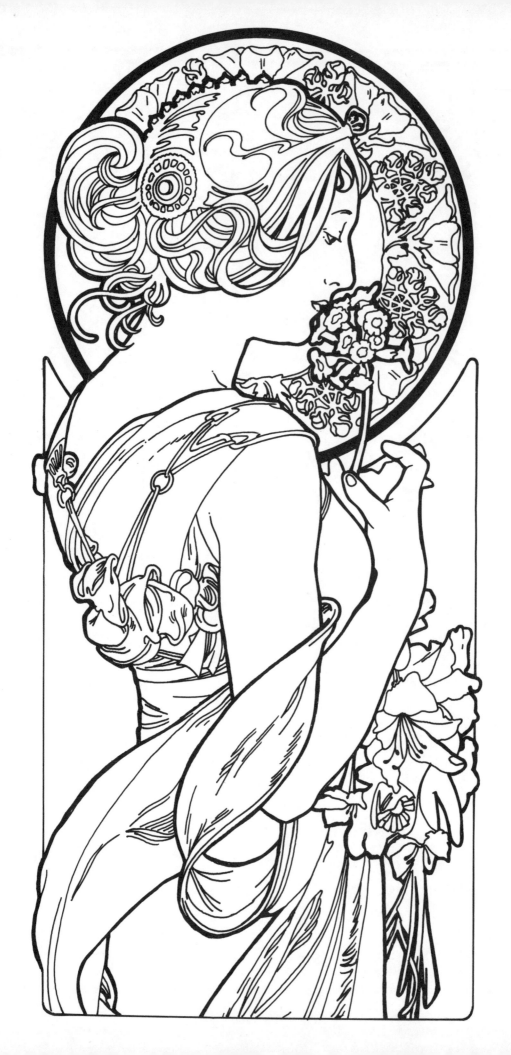

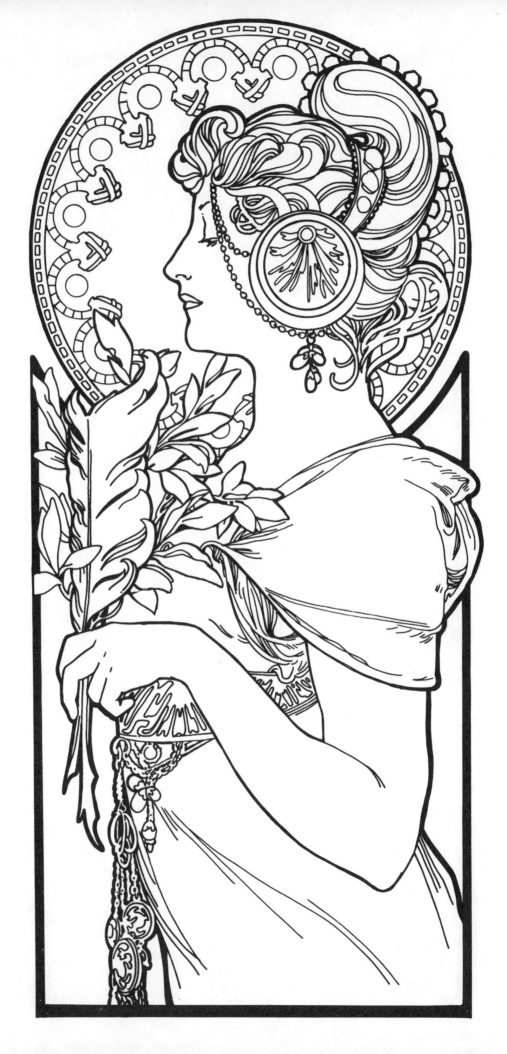

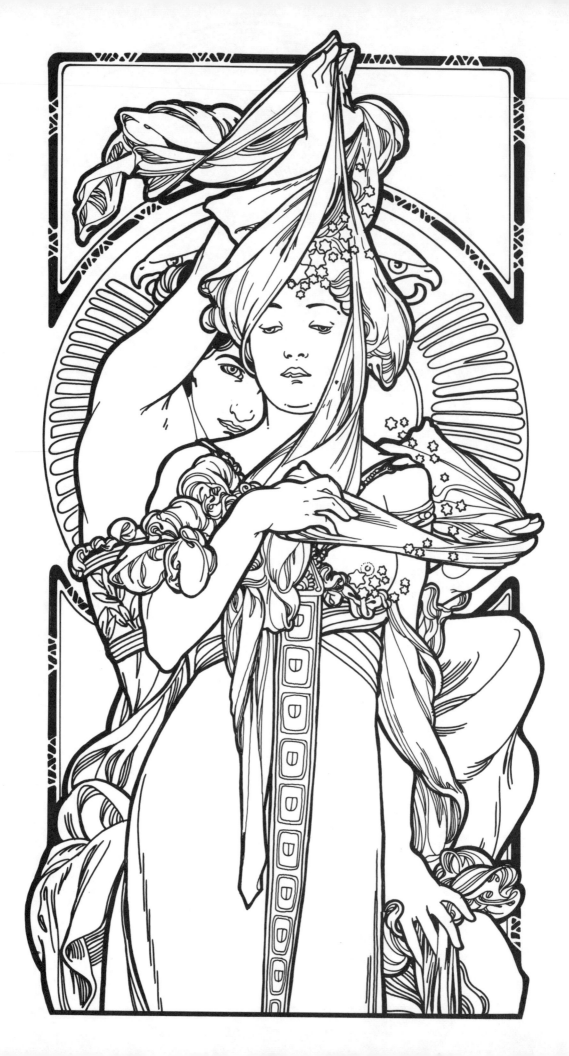

14

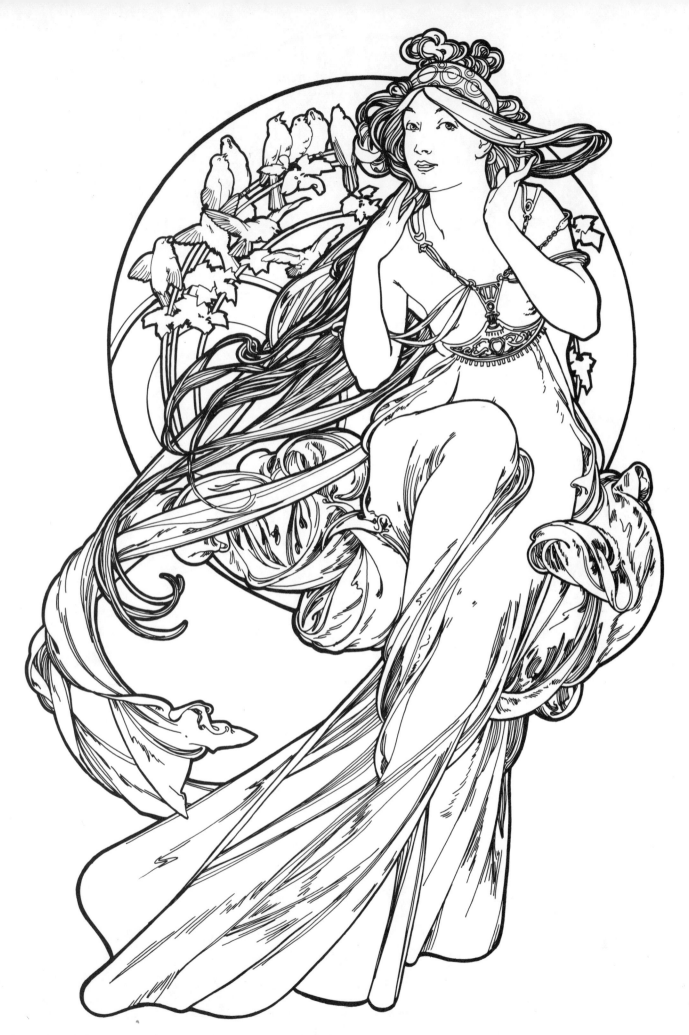

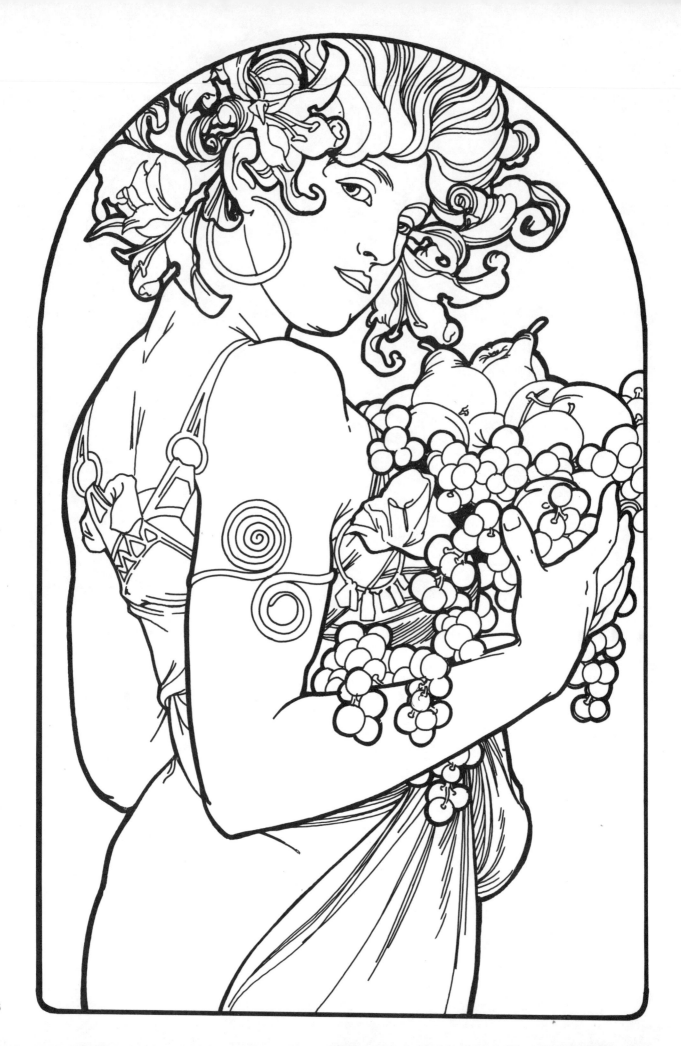

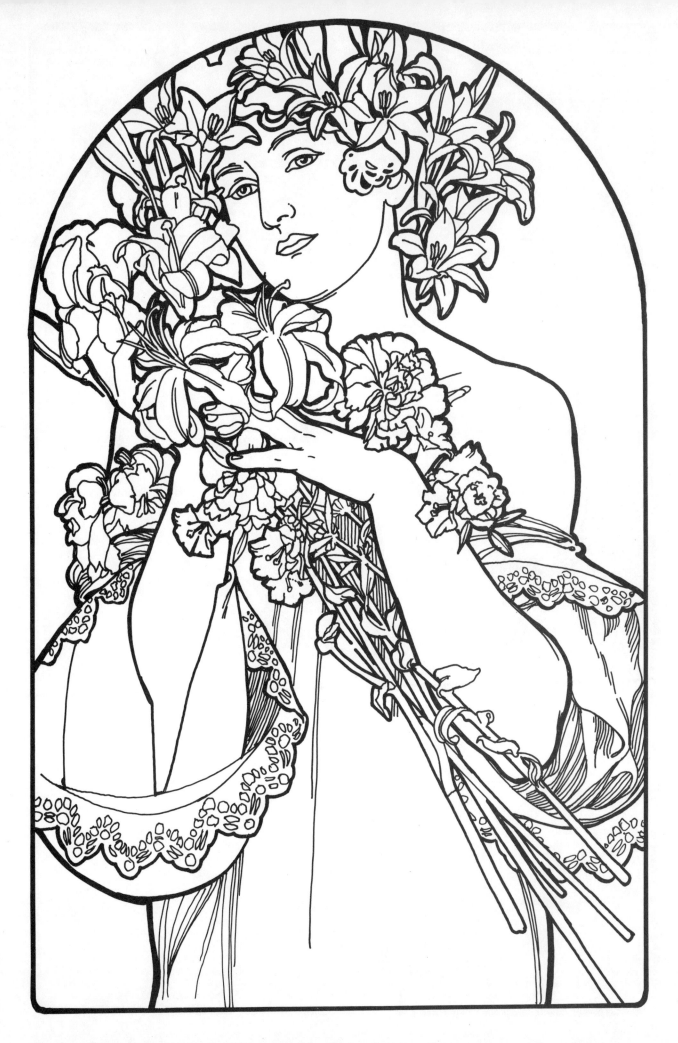

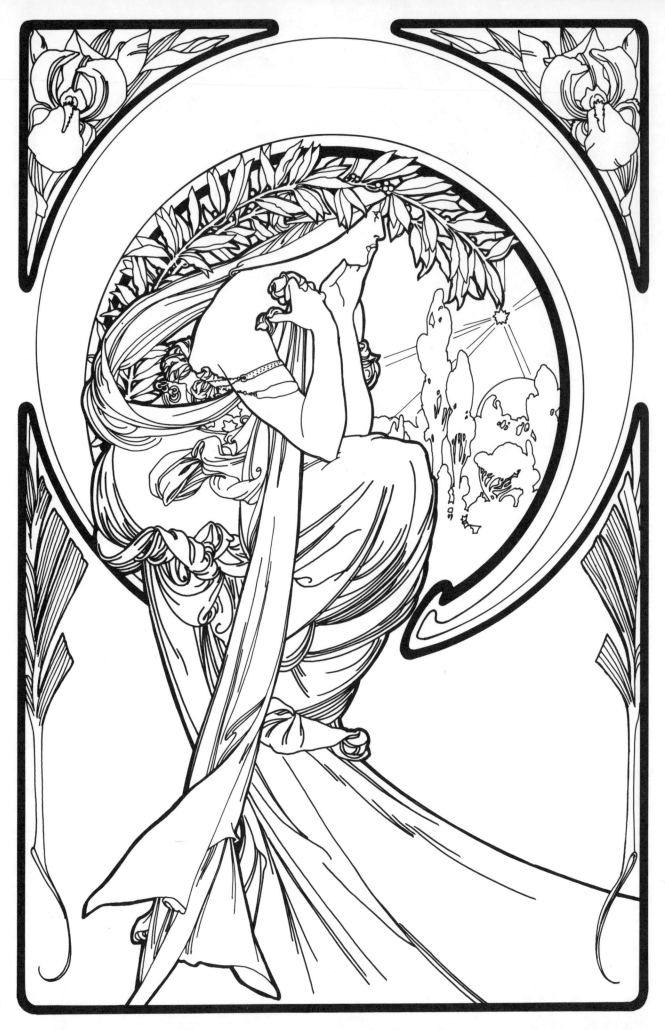

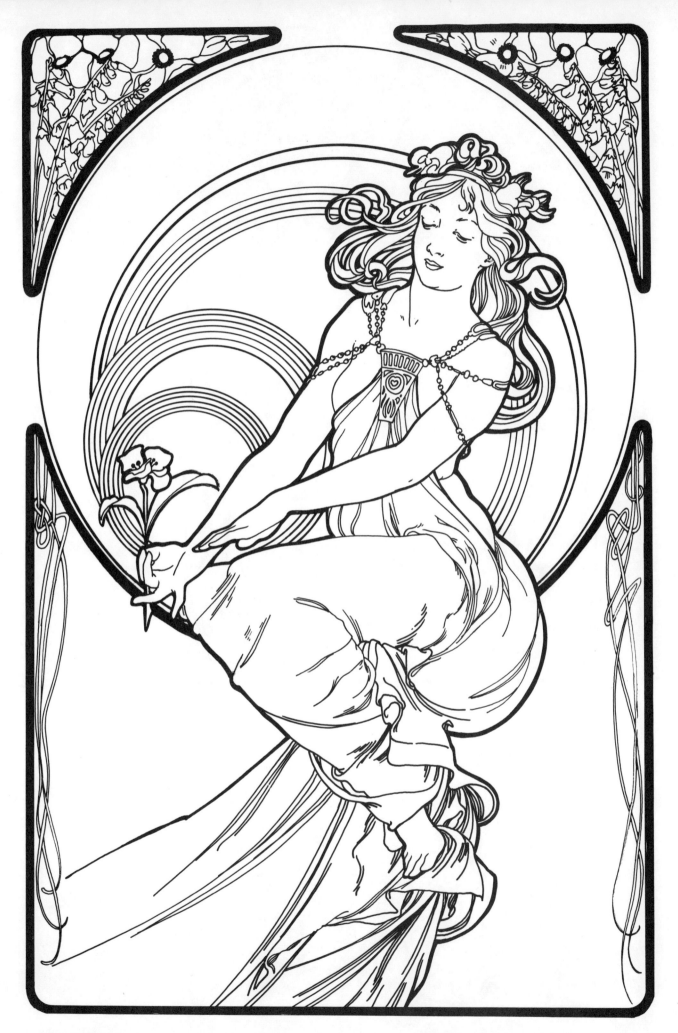

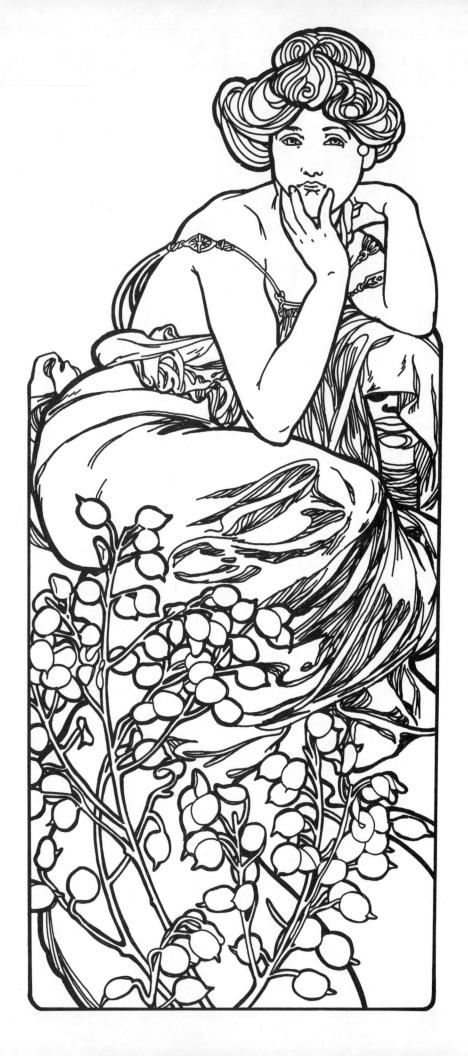

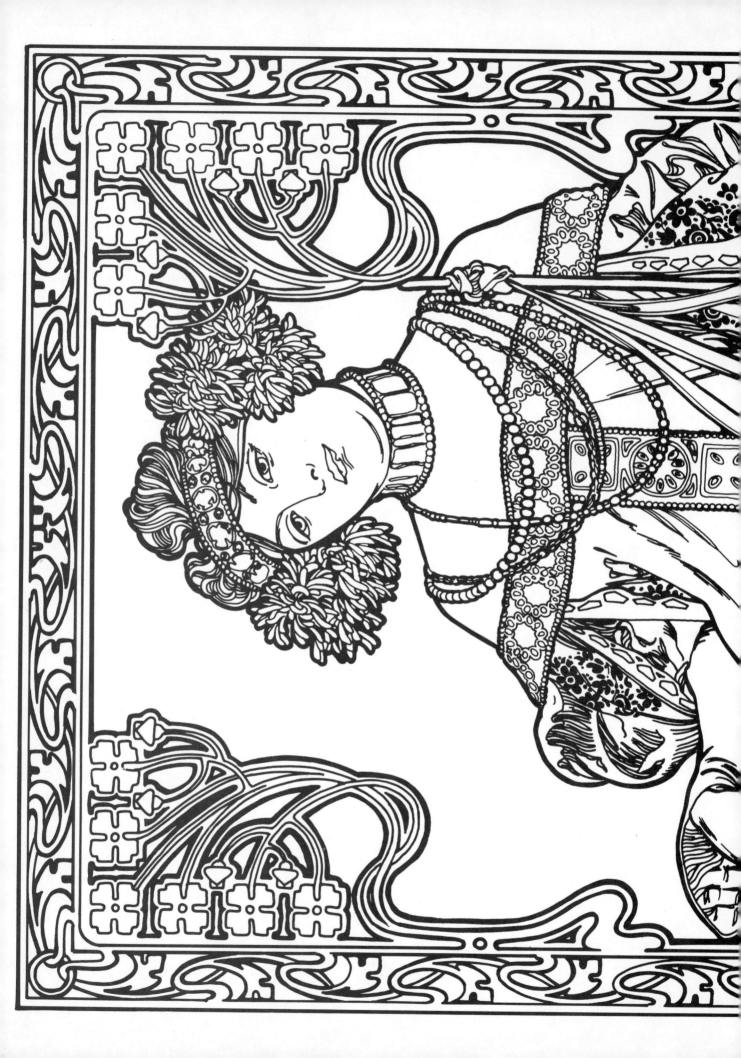

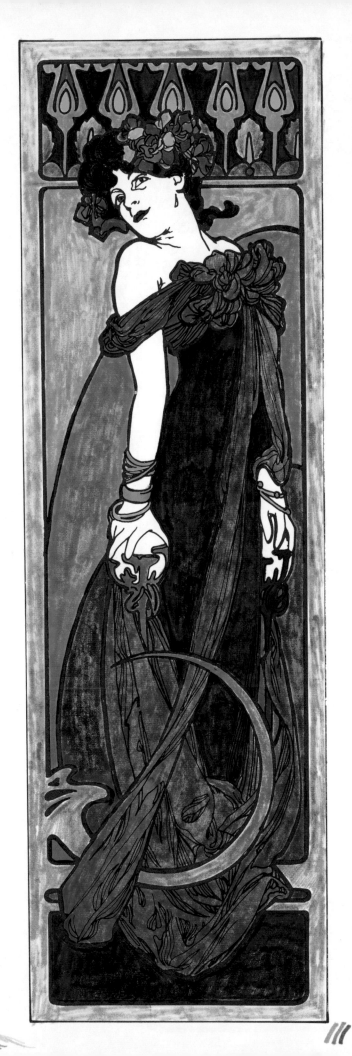
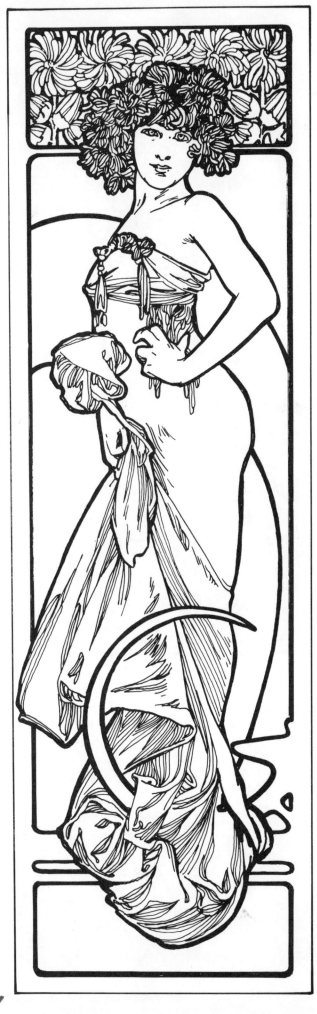

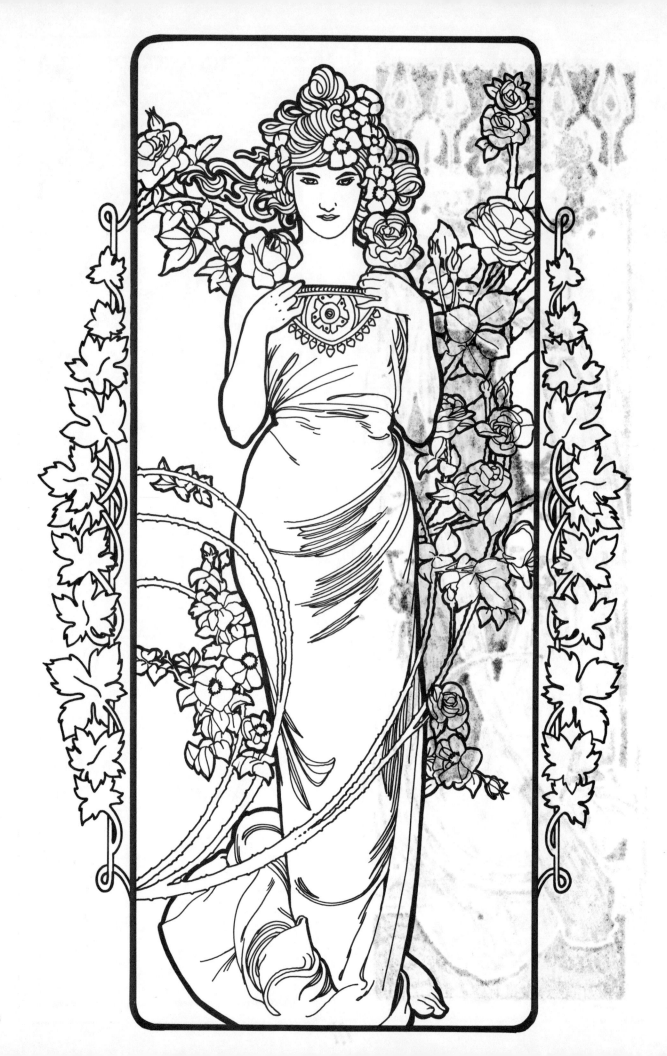

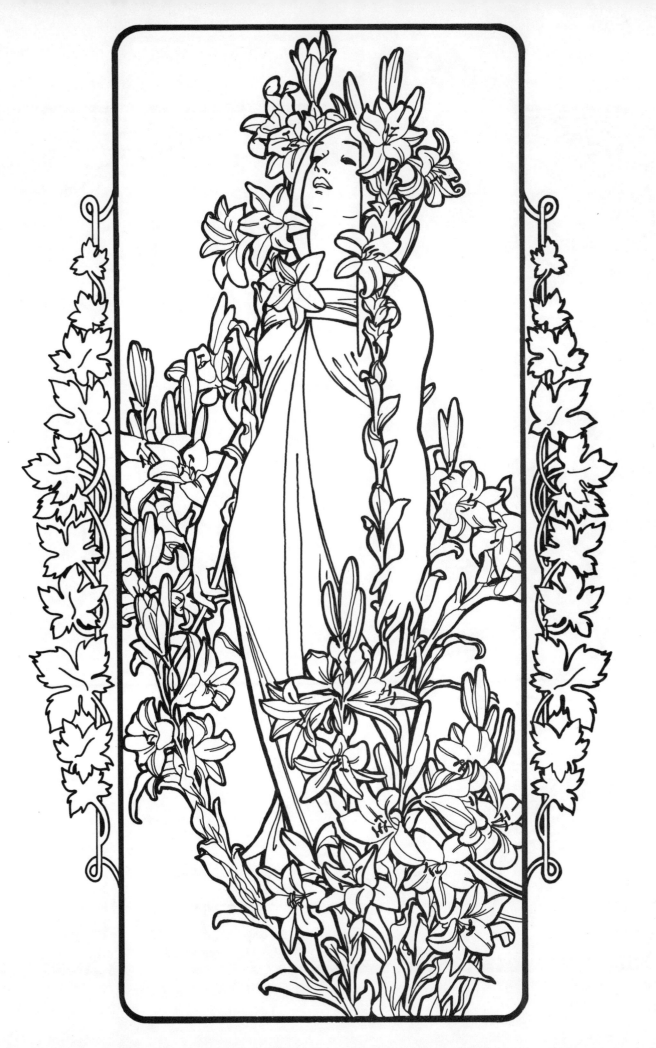

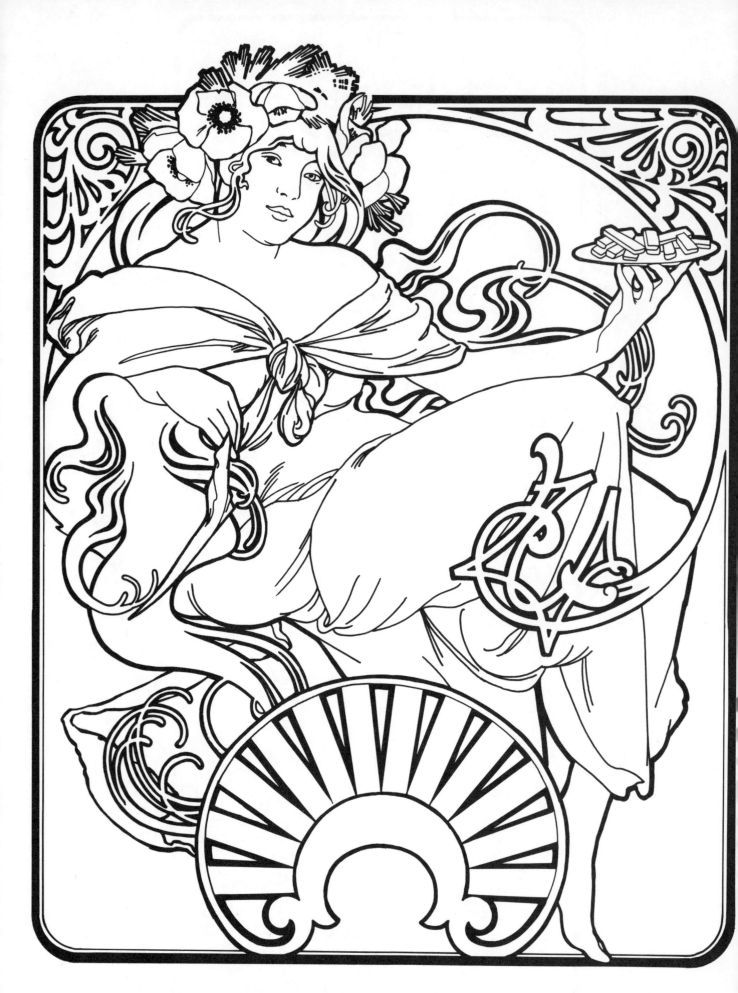

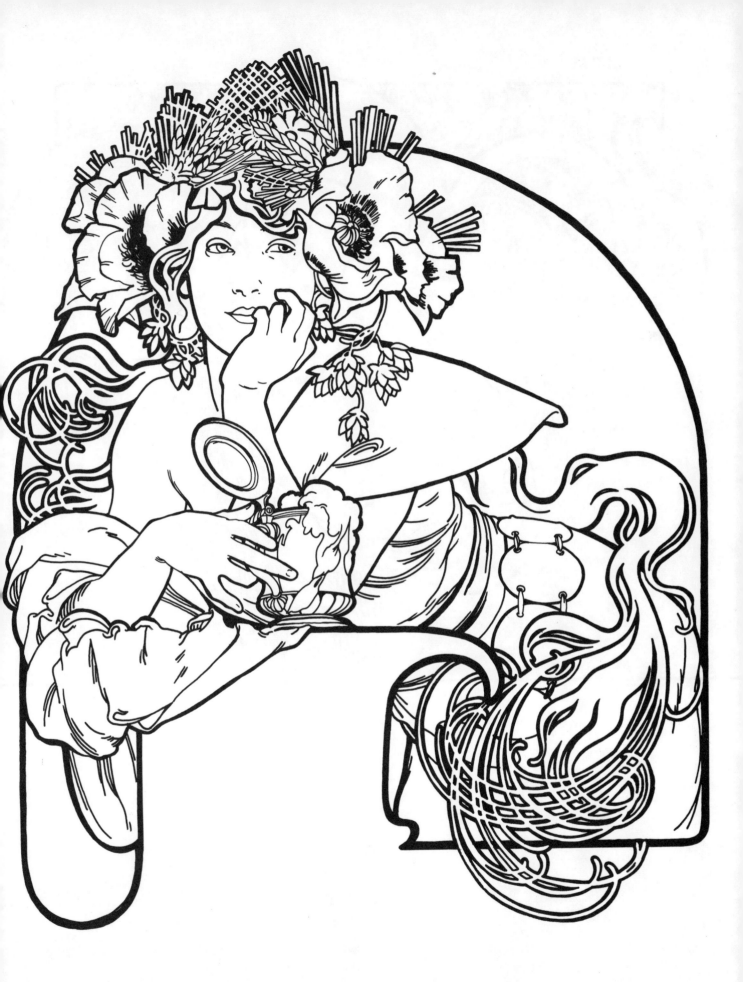

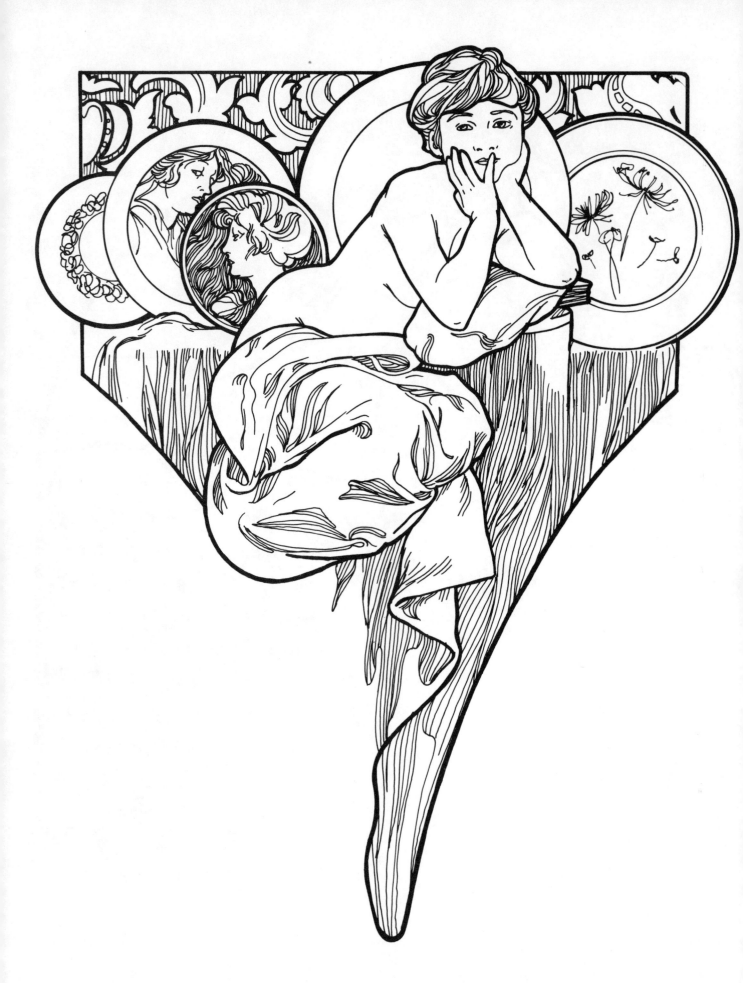

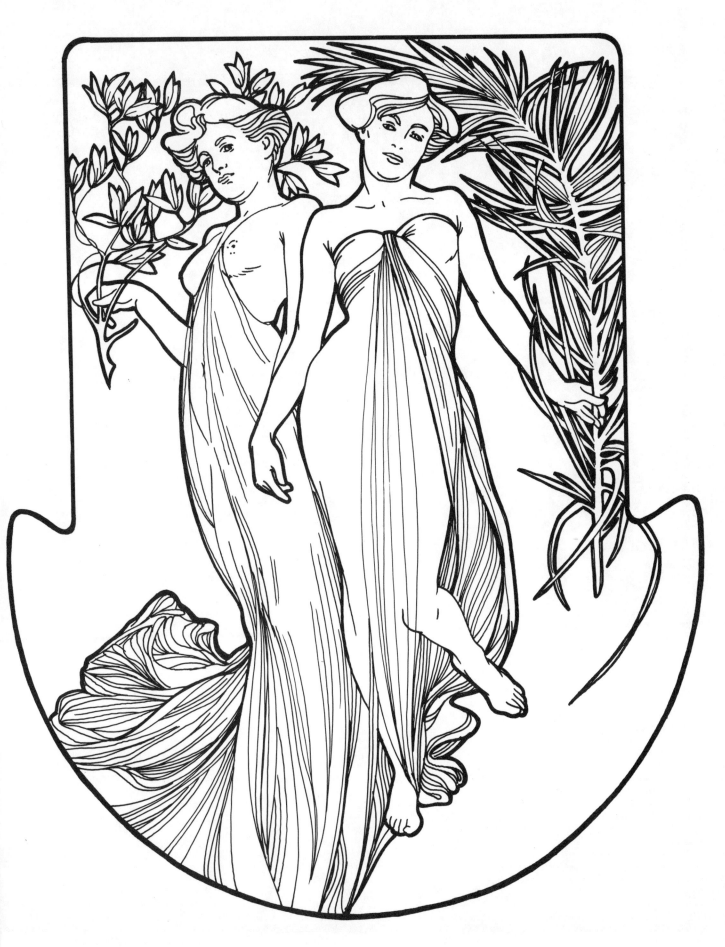

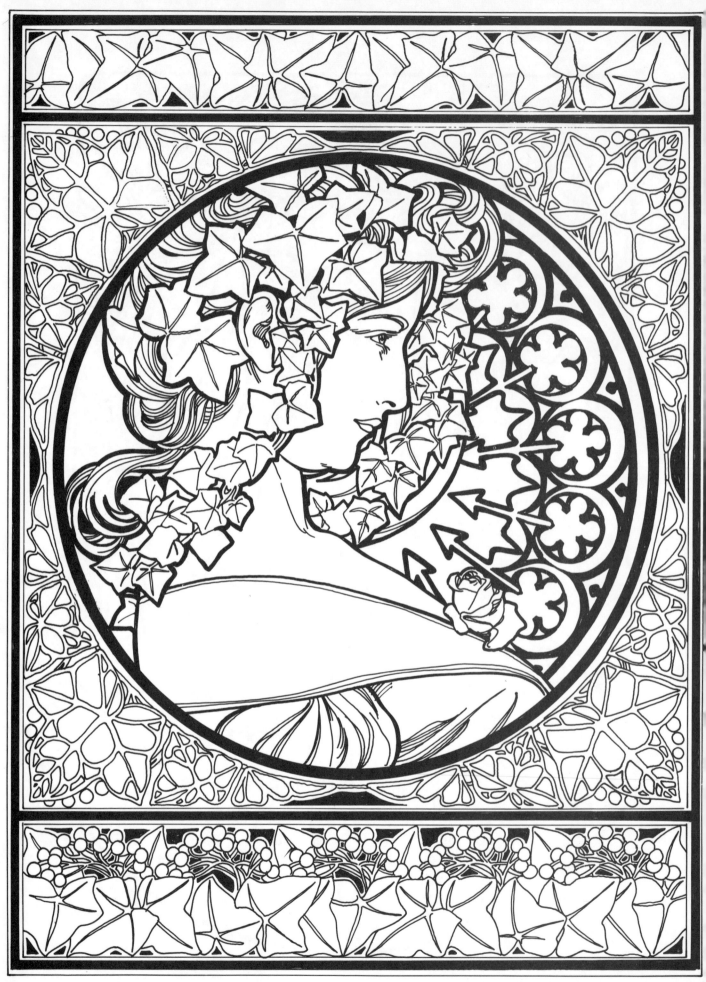

34

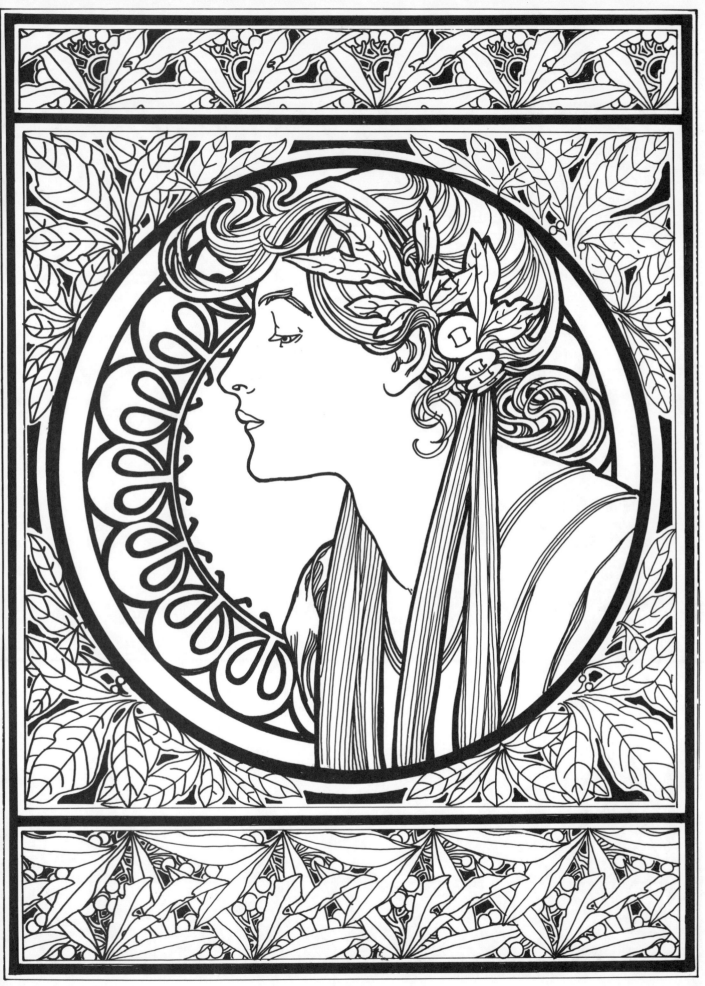

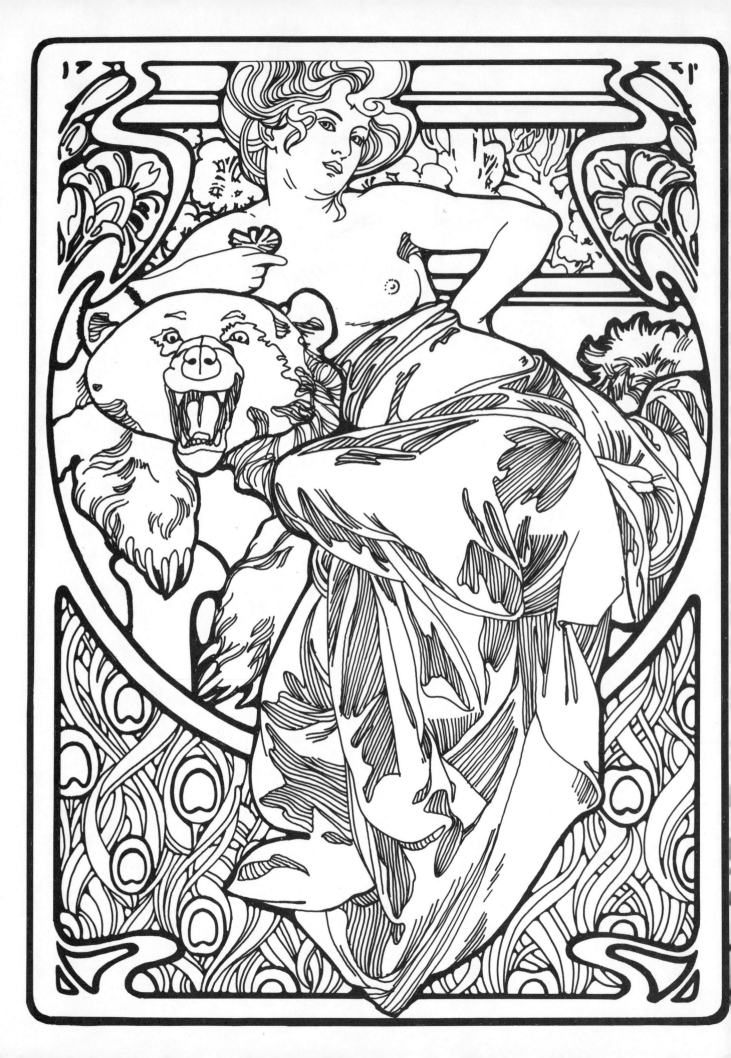

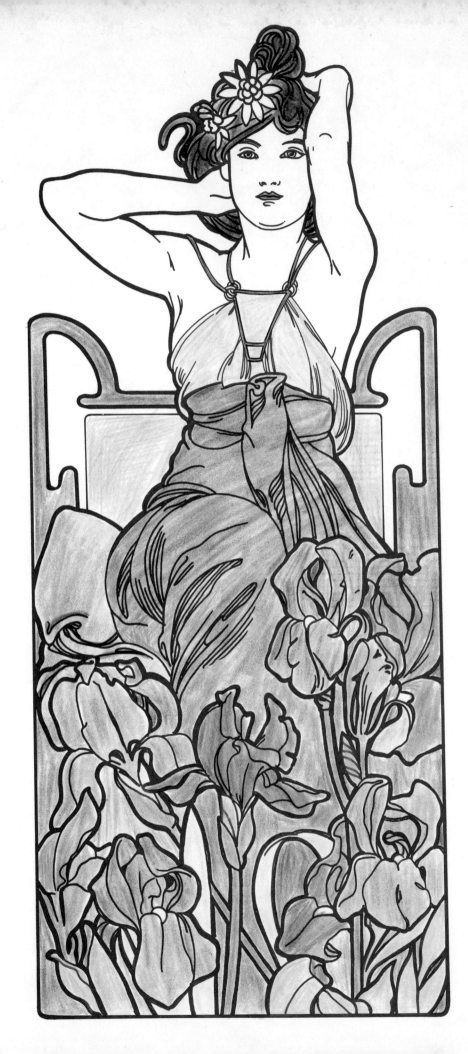

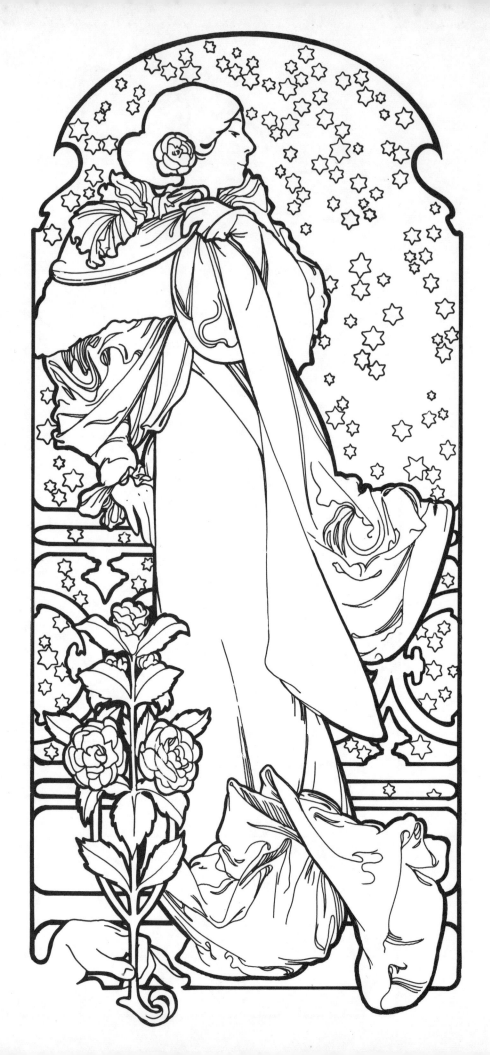

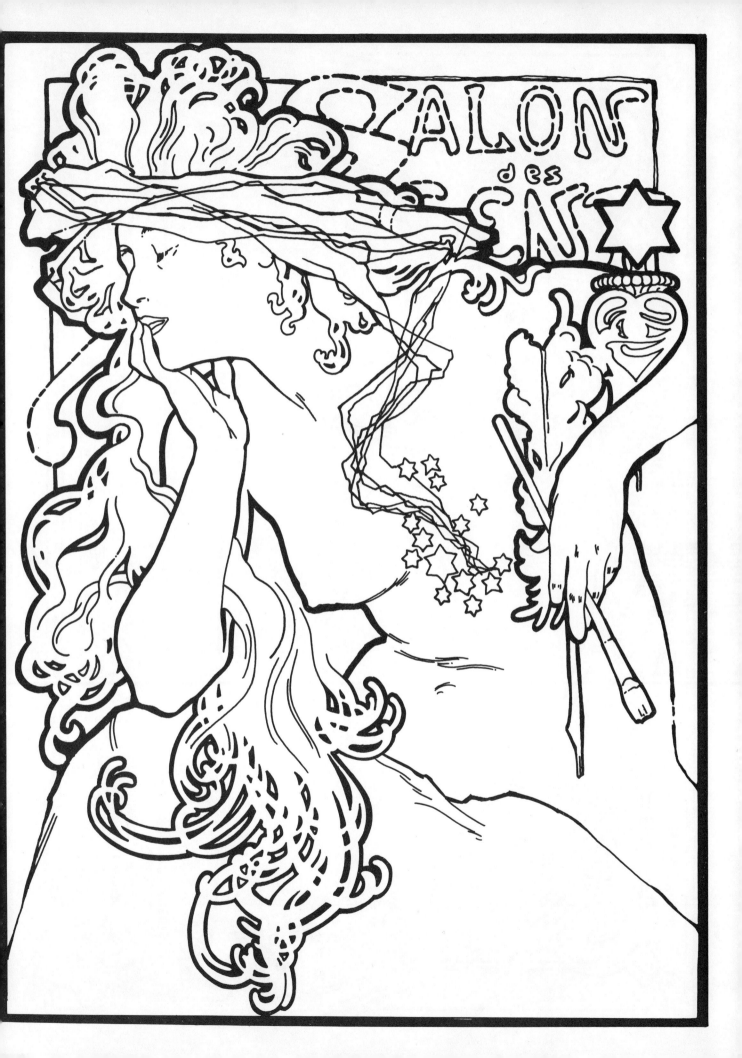

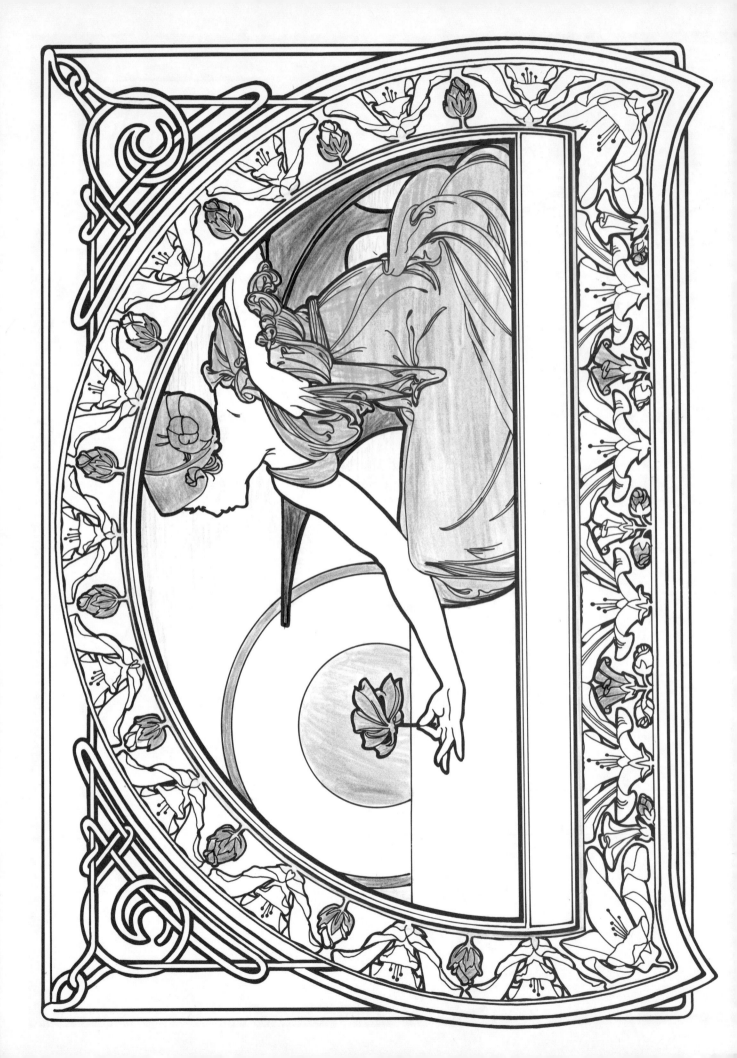

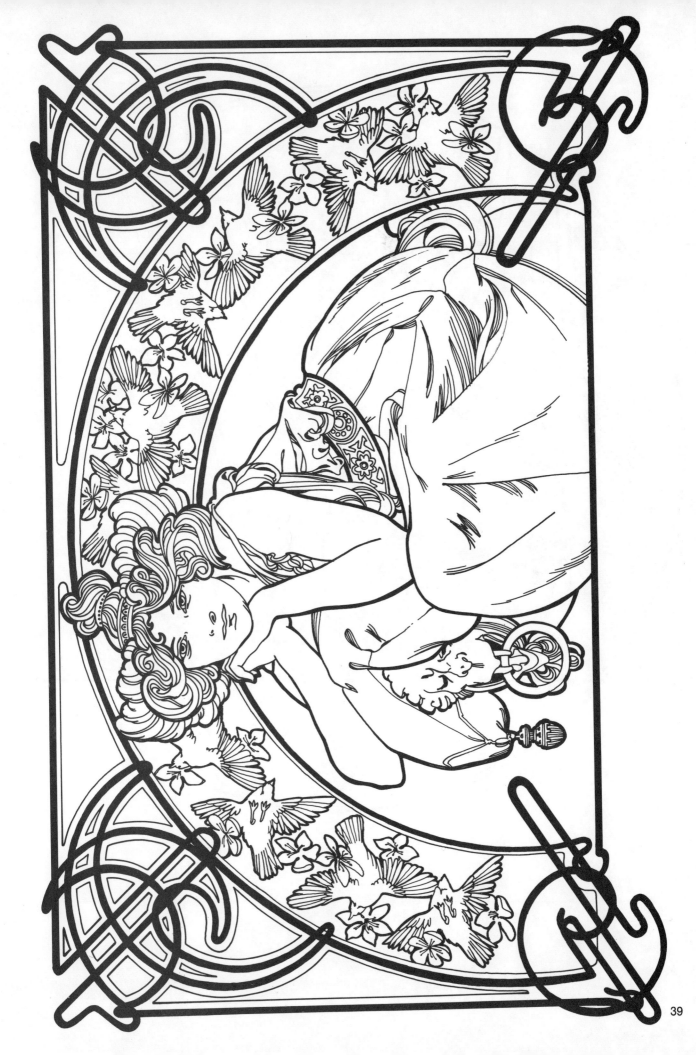

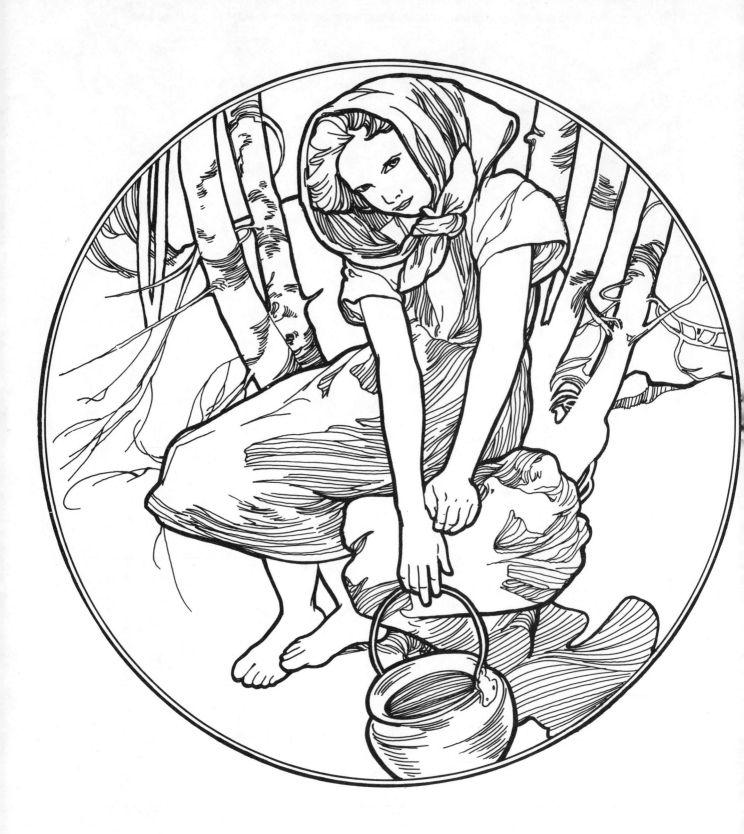

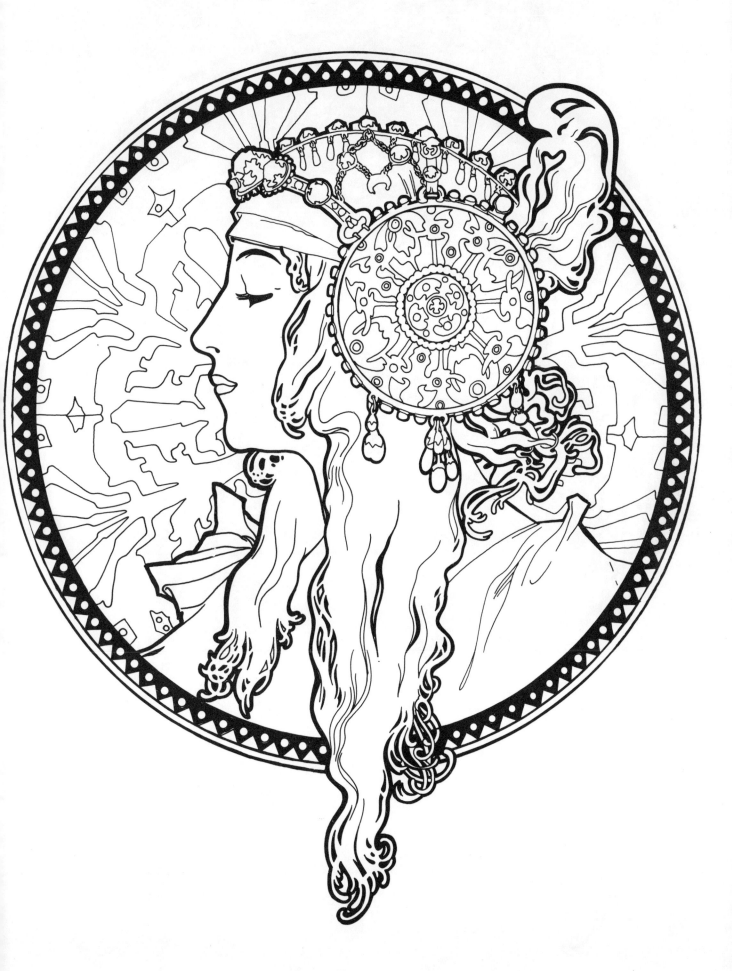

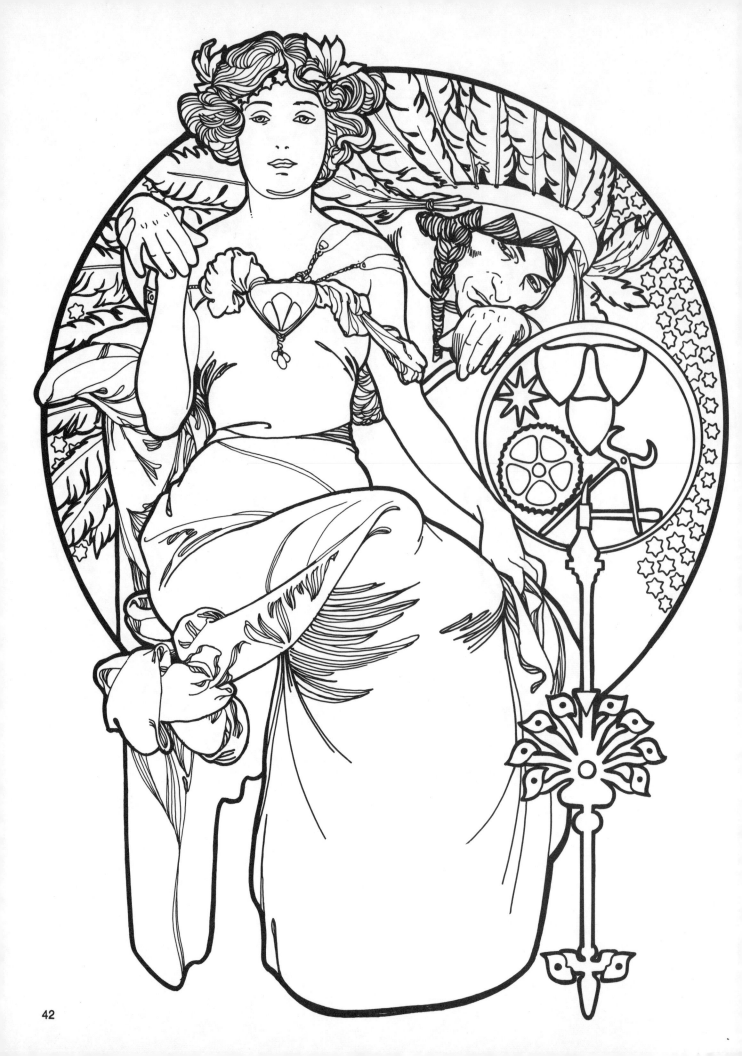

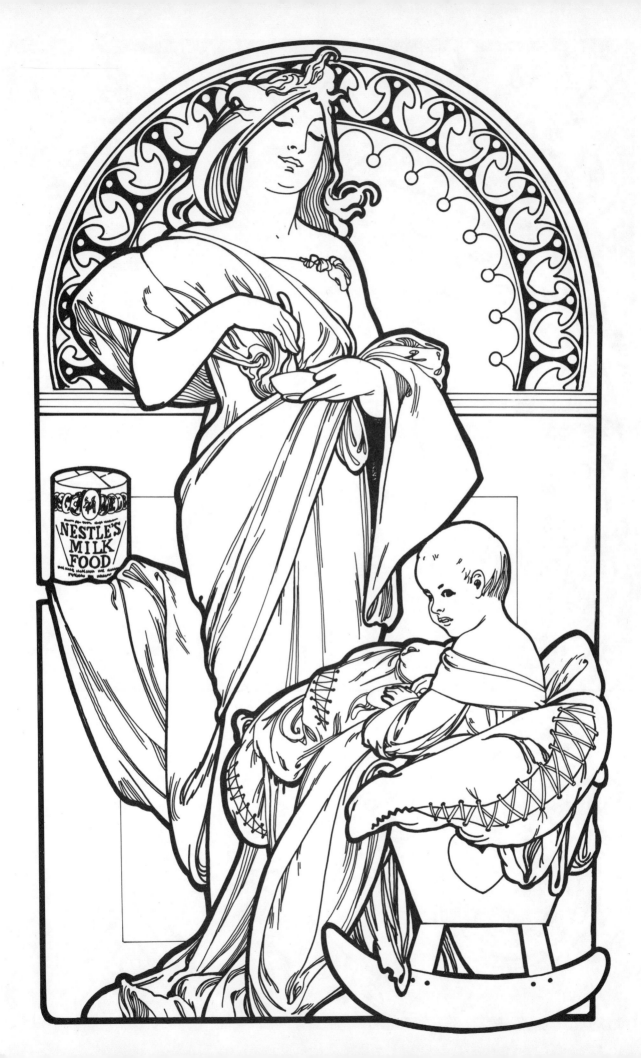

The text on the milk can reads: NESTLE'S MILK FOOD

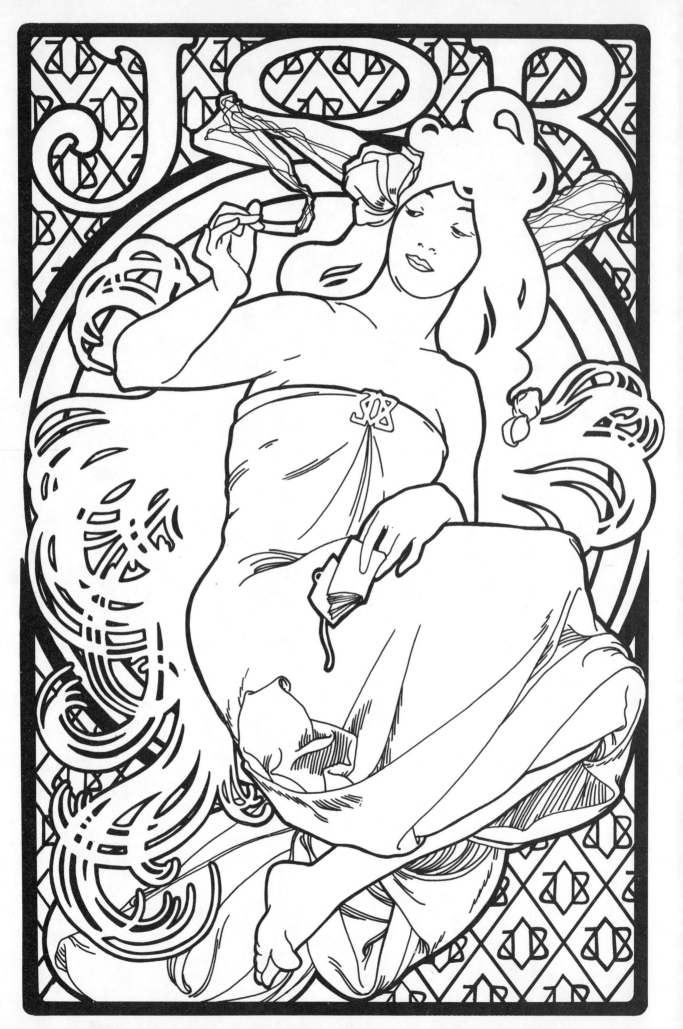

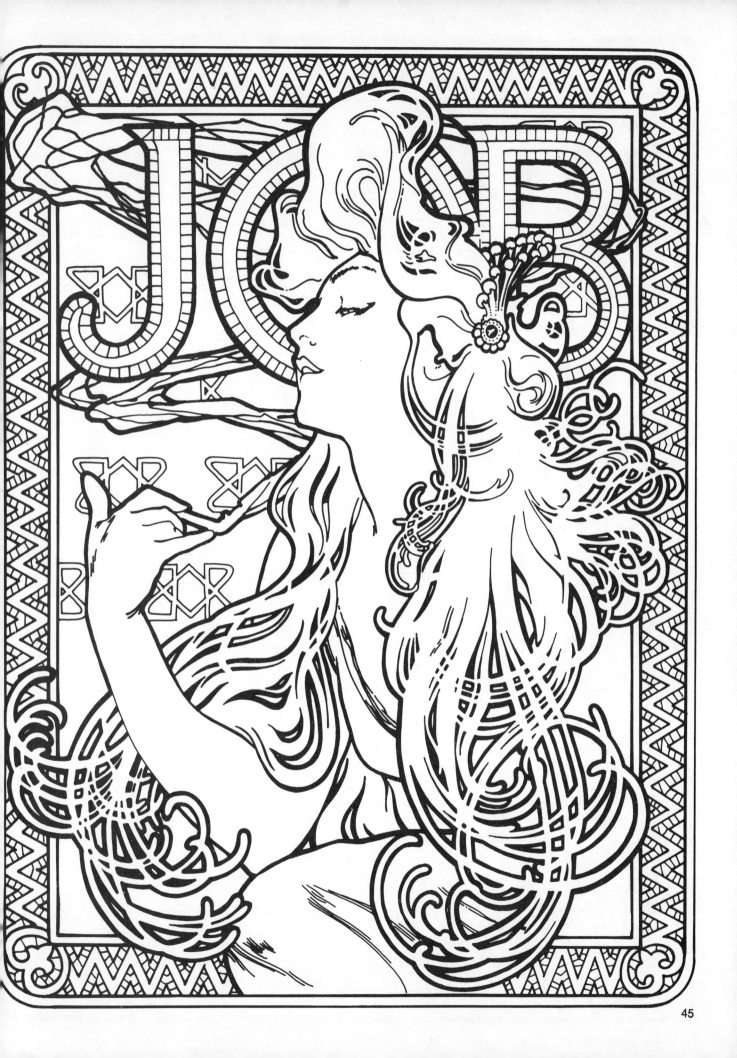

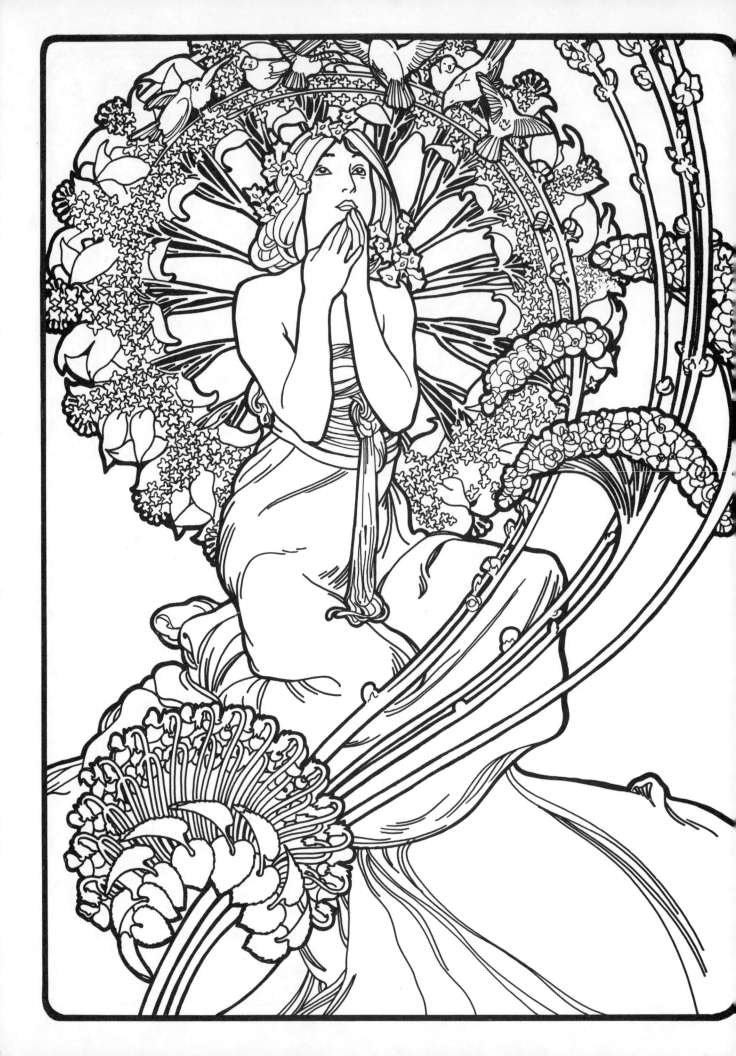

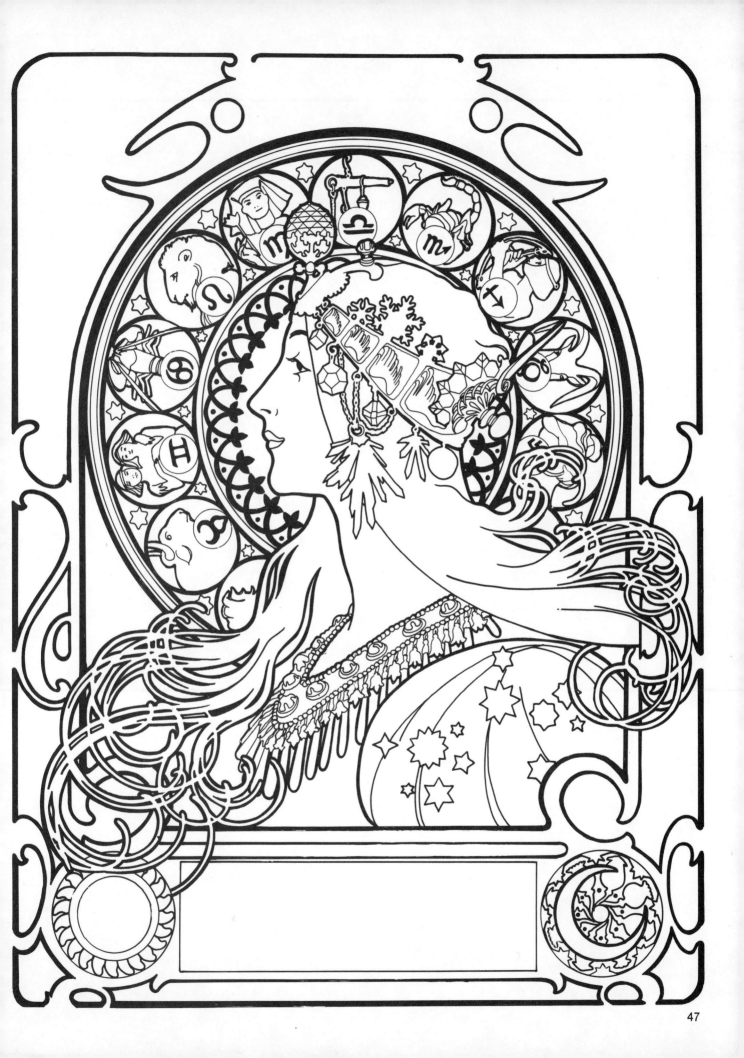